Islamic Illustration

(SHAHIFAH) RIZKI RAMADHANI

Copyright © 2015 Shahifah

All rights reserved.

DEDICATION

A'udzu billaahiminasy syaithonirojiim,
Bismillahirohmanirohiim,

To Islam.

CONTENTS

Bismillahirohmanirohiim,
All contents of illustration related onto Islamic.

ACKNOWLEDGMENTS

Bismillahirohmanirohiim,

QS. Al-Qadr (97); 1:
Innaaa anzalnaahu fii lailatiil qodr.
Translation:
We have indeed revealed this (Message) in the Night of Power.

QS. Al-Qadr (97); 2:
Wamaaa adrookamaa lailatuul qodr.
Translation:
And what will explain to thee what the night of power is?

QS. Al-Qadr (97); 3:
Lailatuul qodr khairummin alfi syahr.
Translation:
The night of Power is better than a thousand months.

QS. Al-Qadr (97); 4:
Tanazzaluul malaaaaaa-ikatu waarruuhu fiihaa bi idzni robbihim min kulli amr.
Translation:
Therein come down the angels and the Spirit by Allah's permission, on every errand.

QS. Al-Qadr (97); 5:
Salaamun hiya hattaa mathla'iil fajr.
Translation:
Peace!... This until the rise of morn!

Shodaqollaahul 'adziim.

Author, 2 Rabiul Awal 1437 Hijriah
(Shahifah) Rizki Ramadhani

Hijaiyah Number

Time of Shalat

Time

Weather

Hot

Month of Hijaiyah

Hijriah

Muharram

www.ingramcontent.com/pod-product-compliance
Lightning Source LLC
Chambersburg PA
CBHW040920180526
45159CB00002BA/553